# Our Highland Home

# Our Highland Home

Jeanne Cannizzo

# Victoria and Albert in Scotland

National Galleries of Scotland
Edinburgh · 2005

Published by the Trustees of the
National Galleries of Scotland to
accompany the exhibition *Our Highland
Home: Victoria and Albert in Scotland*
held at the Scottish National Portrait
Gallery, Edinburgh, from 18 March
to 5 June 2005.

ISBN 1 903278 58 9

Designed by Dalrymple
Typeset in Monotype Haarlemmer
Printed by OZGraf in Poland

Cover: Dress Stewart tartan

# Contents

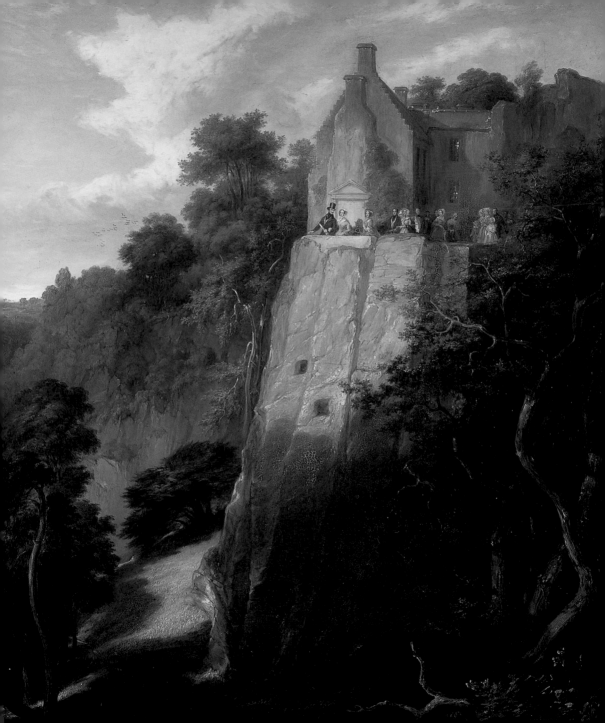

# Foreword

Queen Victoria first visited Scotland in 1842 and was greeted as enthusiastically as her uncle King George IV had been on his visit twenty years earlier. The pleasure she and her consort, Prince Albert, derived from their regular contacts with Scotland and its people led to the purchase of their own estate on Deeside in 1852.

This book, written by Dr Jeanne Cannizzo to accompany the exhibition *Our Highland Home: Victoria and Albert in Scotland,* plots the queen's love affair with Scotland, tracing its roots to both Victoria's and Albert's childhoods. Balmoral was for both, like Ellen's Isle in Sir Walter Scott's *The Lady of the Lake*, a place where the constrictions of formal court life could be abandoned for a simple, innocent, idyllic existence. Prince Albert's premature death in 1861 ended that idyll, but Victoria continued to love the place which she and Albert had created and where they had known such happiness.

We wish to convey our thanks to those involved with this project as the exhibition would not have been possible without the generous support of the many lenders, both public and private. Also, our thanks to the Arts and Humanities Research Board for their assistance with this show. Finally, thanks go to Dr Jeanne Cannizzo, the exhibition curator, and the staff of the National Galleries of Scotland who have been involved with this exhibition, in particular, Susanna Kerr, who organised the show.

SIR TIMOTHY CLIFFORD
*Director-General,*
*National Galleries of Scotland*

JAMES HOLLOWAY
*Director, Scottish National*
*Portrait Gallery*

William Allan 1782–1850
*Queen Victoria and Prince Albert at*
*Hawthornden, 14 September 1842,* 1844
Scottish National Portrait Gallery

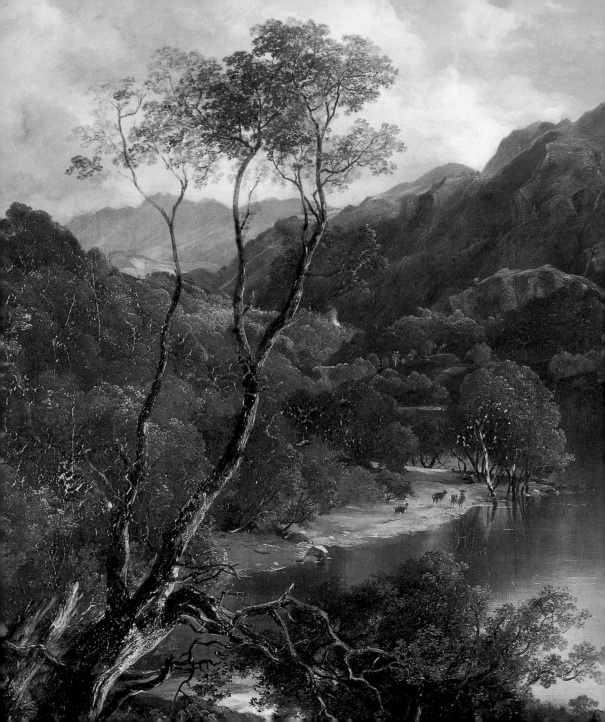

*I cannot reconcile myself to be <u>here</u> again, and pine for my <u>dear</u> Highlands, the hills, the pure air, the quiet, the retirement, the liberty.*

**Queen Victoria writing to her uncle the King of the Belgians, 8 October 1844, Windsor Castle**

The attachment of Queen Victoria and Prince Albert to Scotland was deep, sincere, and long lasting. It was also the product of a complex series of family histories, political and personal interactions, and artistic and literary influences.

Even before they ever saw a Scottish loch, they were attuned to the romance of the Highlands. Victoria adored the work of Sir Walter Scott (1771–1832) and thought him the 'beau ideal' of a poet. When she was a child her governess read to her from Scott's novels and poems, and she thus formed a romantic impression of the social and political upheavals of Scotland's past. In 1828 she was presented to the 'Wizard of the North' (as Scott was often called) when he was invited to dine with her mother at Kensington Palace. The first novel she read as a young woman was *The Bride of Lammermoor* and she spent the night before she became queen reading a biography of Sir Walter Scott.

When she and Albert first came to Scotland, in 1842, they visited many of

the sites associated with Scott's
works. Victoria read Scott's poem
*The Lady of the Lake* several times on
this visit. Albert wrote to Duchess
Caroline of Saxe-Gotha-Altenburg
that 'Scotland has made a most
favourable impression upon us both
… Every spot is connected with some
interesting historical fact, and with
most of these Sir Walter Scott's
accurate descriptions have made us
familiar.' After they returned home,
Albert commissioned a series of
frescoes to decorate a cottage in the
garden of Buckingham Palace; one of
its three rooms was devoted to scenes
from the Waverley novels.

**1**

Horatio McCulloch 1806–1867
*Loch Katrine*, 1816
Perth Museum and Art Gallery, Perth & Kinross
Council

*Loch Katrine is the setting for Scott's
poem* The Lady of the Lake *which
Victoria read to her husband during their
first visit to Scotland. McCulloch's heroic
painting mirrors Scott's ideal of a
secluded sanctuary of peaceful beauty.*

Sir Edwin Landseer (1802–1873) appears to have had the artistic equivalent to Sir Walter Scott's literary influence on Victoria and Albert, for they undoubtedly saw the Scottish Highlands and their inhabitants through Landseer's own sentimentalising gaze. Robert Burns (1759–1796) and his fellow 'ploughmen' poets had valued the experiences and sentiments of the common people, and an even greater reading public imbued those who led a simpler, usually rural, way of life with a kind of moral superiority over workers in the cities of a modernising economy. Artists were quick to respond to these sensibilities, and to the tastes of a growing middle class,

with paintings celebrating 'peasants', their cottages and handiworks. The works of Landseer and other artists, with Scottish themes, were popular with a public attuned to the pleasures of home and hearth. This included both Victoria and Albert.

Besides the expressly literary and artistic depictions that provided Victoria and Albert with a lens through which to view the Highlands, it was the rise of popular ethnographic texts in the 1830s and 1840s, some lavishly illustrated, that brought ideas and images of the clans and their 'picturesque' kilts and tartans alive for those both south of the border and abroad. Many of these early texts can be found

**2**

Sir Francis Grant 1803–1878
*Sir Edwin Landseer* (1802–1873)
By courtesy of the National Portrait Gallery, London

*Over the many years of his friendship with his royal patron, Landseer produced a significant number of paintings of the royal family at their Highland retreat. While working at Balmoral, he was allowed to dine with the queen, a privilege not often extended to visiting artists.*

in the Balmoral library inventory made in 1901, the year Victoria died. Even as a child, Victoria exhibited an intense interest in 'foreigners' and those who were far removed from her own lifestyle. She was much taken with national costumes, and regularly sketched the 'traditional' dress of various country people. Later she was to insist that her ghillies and keepers at Balmoral wore Highland dress, another facet of her enthusiasm for the 'folkloric', and of her interest in amateur ethnography.

**3**
_____

**William Simson 1800–1847**
*Interior of a Cottage, Killin, August 1833*
National Gallery of Scotland, Edinburgh

*The Dundee-born artist depicts an idealised image of homely pleasures and womanly virtues. Killin was one of the places Victoria and Albert visited on their first trip to Scotland in 1842.*

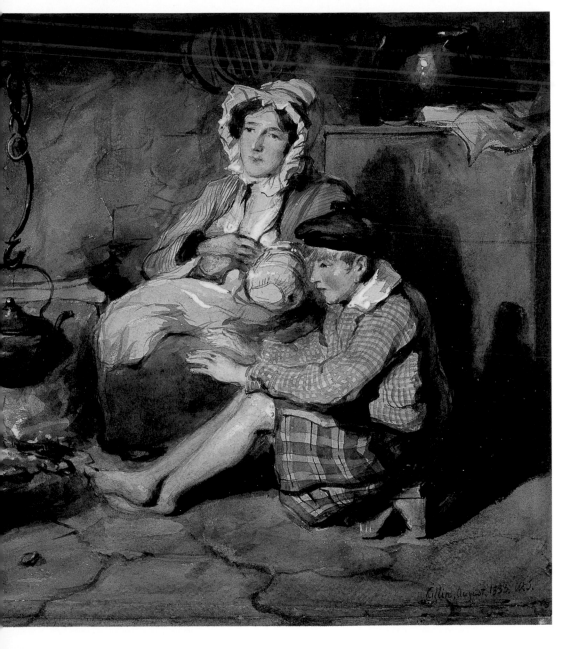

# First Visit, First Views

*We then came in sight of the Scotch coast, which is very beautiful, so dark, rocky, bold, and wild, totally unlike our coast ... numbers of fishing boats (in one of which a piper was playing) and steamers full of people came out to meet us, and on board one large steamer they danced a reel ...*

Queen Victoria's journal entry,
31 August 1842

When the royal couple first visited Scotland in 1842, they were already well imbued with a romanticised appreciation of the Highlands. This initial trip was almost accidental, in that a state visit to Brussels was cancelled when the death of the Duke of Orleans plunged the Belgian court into mourning. A public tour of Scotland was substituted.

The Duke of Buccleuch became Victoria and Albert's first host when Holyroodhouse was not considered comfortable enough and there was an outbreak of scarlet fever in the capital. Albert thought both the town of Dalkeith and its people looked very German. It was at Dalkeith Palace, the duke's home, that Victoria first ate oatmeal porridge and Finnan haddies, both of which she found very good. While at Dalkeith, she held a levee for members of the Scottish aristocracy and local gentry in a drawing room, converted into a reception hall, which was furnished with the throne upon which George IV had sat while on his visit in 1822:

**4**

Sir John Watson Gordon 1788–1864
*Walter Francis, 5th Duke of Buccleuch
and 7th of Queensberry (1806–1884)*
In the collection of the Duke of Buccleuch
& Queensberry KT

*The Duke of Buccleuch was the royal
couple's first host in Scotland at
Dalkeith Palace as the Palace of
Holyroodhouse was not considered to be
comfortable enough, and there was an
outbreak of scarlet fever in Edinburgh.*

**5**

Charles Burton Barber 1845–1894
*Queen Victoria Seated on 'Florrie',
John Brown (1826–1883) in Attendance,
Balmoral in the Distance, 1876*
The Forbes Collection, New York

*The years Victoria and Albert spent
together at Balmoral after their first visit
were to be short. Their family home
provides the backdrop to this scene of
the lonely widow.*

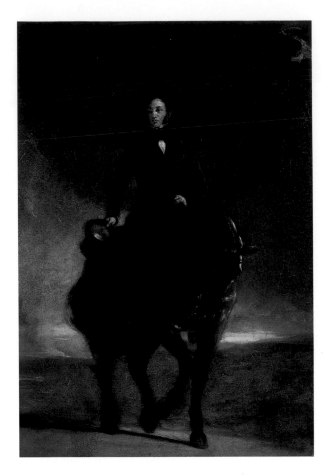

an event masterminded by Sir Walter
Scott.

During the rest of the tour, aristo-
cratic houses were thrown open to
Victoria and Albert where they enjoyed
many displays of Scottish customs,
food and music. At Drummond Castle,
for example, Victoria reviewed the
Highlanders and admired the parterre
and terraced gardens. Albert went out
early in the morning to the Glenartney
deer forest and returned with his first
stag after a days stalking. Both Victoria
and Albert were fêted in a splendid
specially erected pavilion with a star-
spangled roof.

During Victoria's four-day stay at
Taymouth Castle, a certain theatrical-
ity prevailed as the Marquess of
Breadalbane had hired an English firm
to supply decorative heraldic panels,
banners and suits of armour. His
visitors were entranced by the effect of
his firework displays and illuminations,

**6**

Jacob Thompson 1806–1879
*Queen Victoria Reviewing the
Highlanders at Drummond Castle on her
first Visit to Scotland in 1842*
Grimsthorpe and Drummond Castle Trust

*Victoria, accompanied by Lady
Willoughby, reviewed 110 of Lord
Willoughby's Highlanders in the court-
yard at Drummond Castle on
12 September 1842.*

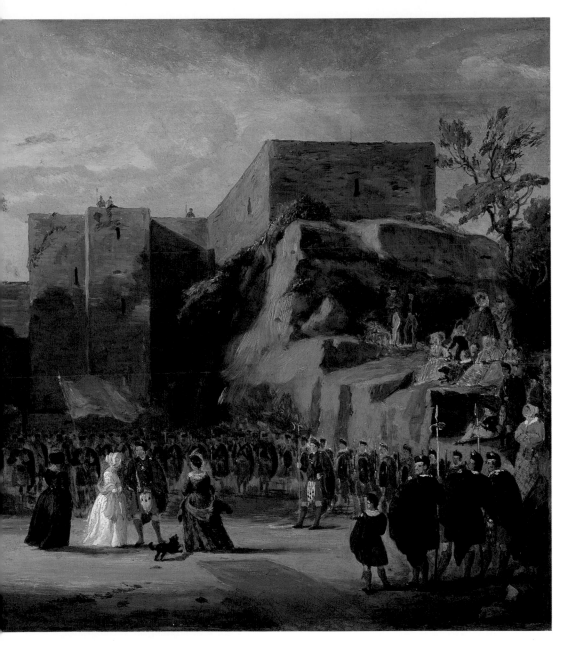

**7**

David Octavius Hill 1802–1870 and
Robert Adamson 1821–1848
*John Ban Mackenzie, Piper to the
Marquess of Breadalbane and the
Highland Society (1796–1858)*
Scottish National Photography Collection
Scottish National Portrait Gallery, Edinburgh

22 *Mackenzie was one of the Marquis of
Breadalbane's personal pipers, and his
son entertained the royal couple with a
display of Highland dancing.*

**8**

Alexander Johnston 1815–1891
*Angus Mackay (1812/13–1859) Piper to
Queen Victoria*
Scottish National Portrait Gallery, Edinburgh

*At the time of this painting in 1840, the
sitter was piper to Walter Campbell of
Shawfield MP and is seen here wearing
the Campbell tartan. The silver plate on
his chanter stock denotes prizes won in
1835 and 1837. He served the queen from
1843 to 1853 and died by drowning in the
River Nith, having escaped from the
asylum at Crichton Royal Hospital in
Dumfriesshire.*

the queen noting in her journal on
7 September, 1842, while at Taymouth:
'I never saw anything so fairy-like.'
There were also nine pipers at the
castle and Victoria noticed that they
played at breakfast, during the morn-
ing, at luncheon, any time she and
Albert went in or out, and before and
during dinner. Confiding in her
journal that they had both become
'quite fond of the bagpipes', on the
recommendation of the marquess she
engaged her own piper, Angus
Mackay, the following year. A shooting
expedition on the moors, with Albert
as honoured guest and gun, returned
with nineteen roebuck, black grouse,

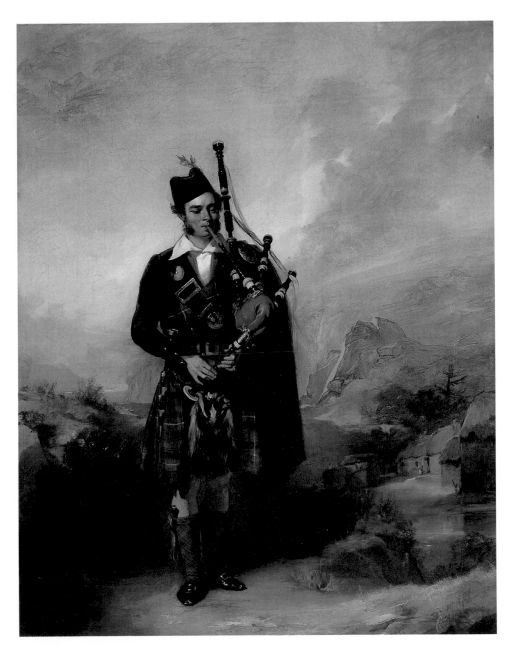

red grouse, capercaillie, partridge,
wood pigeon, twelve hares, one owl
and several rabbits.

Victoria and Albert also attended
many civic receptions where they not
only met local dignitaries, but were
greeted by large and enthusiastic
crowds. Events at Perth, whose popu-
lation was said to have tripled or even
quadrupled during the visit, were
probably the highlight of these more
public aspects of the 1842 tour. Over
1,000 stewards lined the route of the
royal couple's cavalcade. The queen
accepted the keys to the city, presented
to her in front of a huge wooden arch
painted to simulate stone. After her
departure, a civic banquet was held and
thousands of the poor of the city
received a shilling each to mark the
visit.

Victoria and Albert returned to
Scotland in 1844 after a trip to Ireland
was cancelled, allegedly because of
political unrest. So the queen, the
prince and the young princess royal
made a private sojourn at Blair Castle,

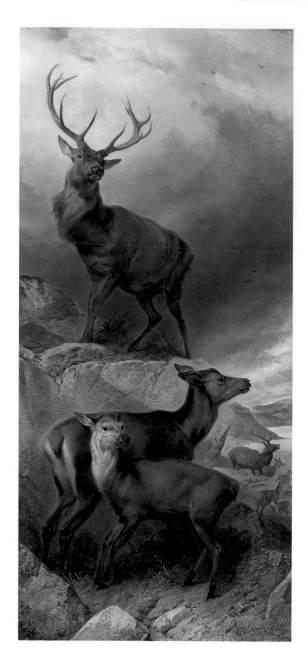

**9**

---

Richard Ansdell 1815–1885
*The Deer Forest*
The Drambuie Collection

*The artist, a keen sportsman, was a
frequent visitor to Scotland. He special-
ised in a range of animal subjects, paint-
ing in much the same style as Landseer.*

24

**10**

### William Brown 1801–1874
*Her Majesty Queen Victoria and Prince Albert Entering the City of Perth, 1842*

Perth Museum and Art Gallery, Perth & Kinross Council. Purchased with financial assistance from the Local Museums Purchases Fund

*The population of Perth was said to have tripled or even quadrupled with the arrival of thousands of spectators from Dundee and the surrounding areas. Cheering, cannon salutes and the pealing of the bells of St John's church resounded along the route of the royal progress.*

which was lent to the royal party while Lord and Lady Glenlyon moved into the house of their estate factor for three weeks. Although a reporter for the *Illustrated London News*, 28 September 1844, managed to fill several pages, he complained that 'the life of secluded retirement which Her Majesty has led since her arrival has not been disturbed by any incident worthy of recording.' It is said to be during this holiday that Victoria first voiced the possibility of a permanent home in the Highlands.

25

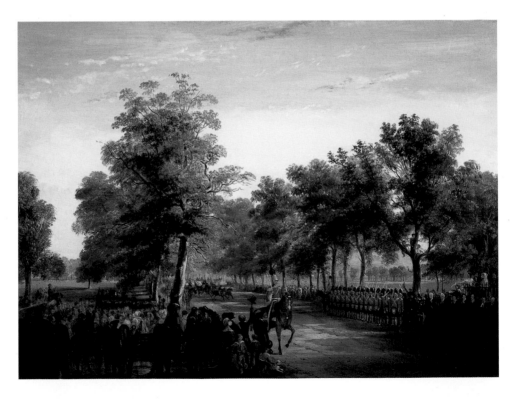

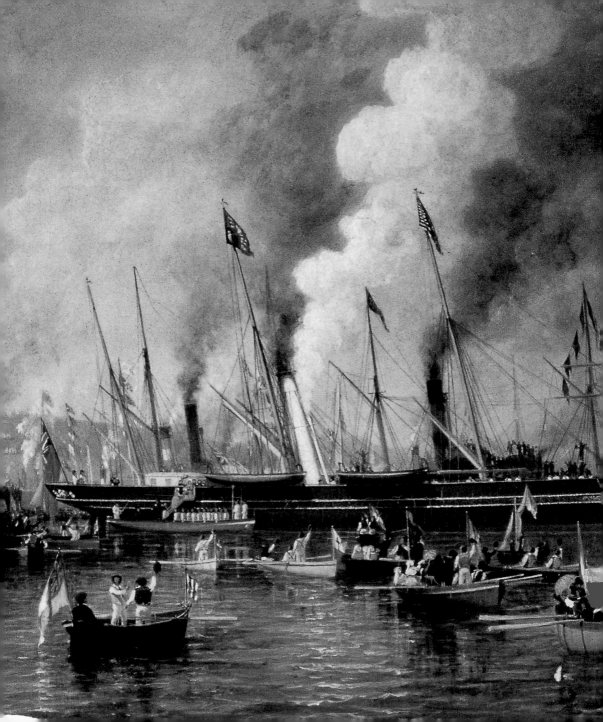

*We then drove on, in our pony carriages, to Ardverikie ... It is quite close to the lake, and the view from the windows, as I now write, though obscured by rain, is very beautiful, and extremely wild. There is not a village, house, or cottage within four or five miles: one can only get to it by the ferry, or by rowing across the lake.*

Queen Victoria's journal entry,
21 August 1847, Ardverikie Lodge

Victoria and Albert made one more visit to Scotland, in 1847, before deciding to lease and then purchase Balmoral Castle. The royal yacht *Victoria and Albert*, launched in 1843, was met by dozens of decorated private vessels as it arrived in the River Clyde. Also in the royal squadron was the steam-tender *Fairy* and a horse-drawn barge, which were used for sightseeing excursions. Contemporary newspaper reports put the number of land-based spectators at 100,000.

This time the royal couple stayed at Ardverikie, the Marquess of Abercorn's shooting lodge on Loch Laggan. *The Scotsman* newspaper, 18 August 1847, noted that 'Her Majesty will not find at this residence, either for herself, or her attendants, any traces of that magnificence and luxury which not only surrounds her in her palaces, but accompanies her to the seats of the nobility.' Indeed, the house was so isolated that some journalists complained it was an 'uncome-atable place'. However, Sir Edwin Landseer did manage to visit the queen here and

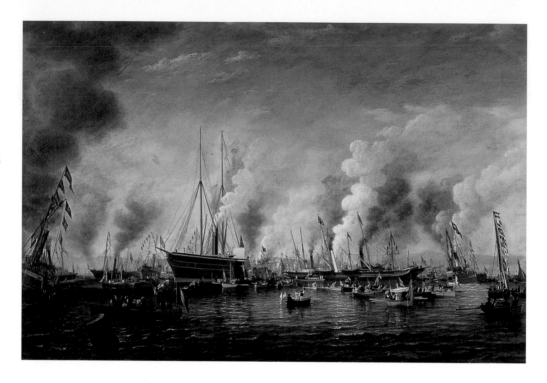

## 11

### William Clark 1804–1883
*The Queen's Visit to the Clyde*
*17 August 1847*

McLean Museum and Art Gallery,
Inverclyde Council

*Victoria and Albert can be seen
embarking from* Fairy, *the tender to
the royal yacht that could enter small
ports and navigate rivers impassable
to the larger* Victoria and Albert. *The*
Fairy *transited the Caledonian Canal
with the queen, the yacht just squeez-
ing through the locks.*

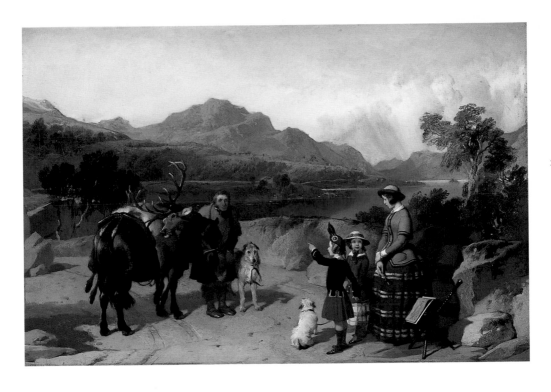

**12**

**Sir Edwin Landseer 1802–1873**
*Queen Victoria Sketching at Loch Laggan, 1847*
The Royal Collection © 2004, Her Majesty Queen Elizabeth II

*Landseer visited Victoria at Ardverikie in September 1847 and later the same year he produced this painting of the royal family in the Highlands, which the queen gave to Albert as a Christmas present. The children are wearing the Highland dress they had worn for their father's birthday on 26 August.*

**13**

Sir Joseph Edgar Boehm 1834–1890
*Throwing the Hammer – Archibald
Brown; Tossing the Caber – William
Thomson; Putting the Stone – John
Thomson; A Runner – Alexander
Campbell, 1869*

The Forbes Collection, New York

*These bronze figures of Highlanders
were personally commissioned by
Victoria from Boehm, a Viennese
sculptor. He received over forty royal
commissions and was appointed
Sculptor in Ordinary to the queen
in 1880.*

produced his first picture of the royal
family in the Highlands, *Queen Victoria
Sketching at Loch Laggan*, which
Albert received as a Christmas gift
from his wife later that year. At the
Highland games which were organised
to celebrate his birthday, Albert wore
Highland dress.

The spectacular scenery
reminded him, in a now familiar
pattern, of his homeland in
Thuringia. He and Charles,
Prince of Leiningen, Victoria's
half-brother who accompanied
them, discussed European

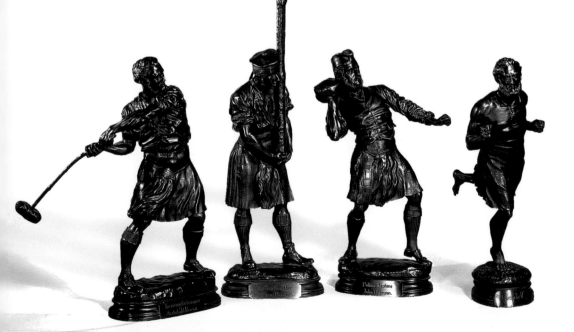

politics for hours while the queen wrote in her journal. This rain-drenched visit led to the couple's discovery of Balmoral, when Sir James Clark, the Royal Physician in Ordinary, extolled the contrasting virtues of the Deeside climate. A native of Banffshire, he had spent several years in the Navy before completing a medical degree at the University of Edinburgh in 1817. He had a long-standing scientific interest in the effects of climate on human health, and had sent his ailing son to stay with Sir Robert Gordon at Balmoral. Clark, who was enduring the Ardverikie weather with the royal party, received a letter from his son who said that Deeside was a tonic for his lungs. Victoria asked Sir James to find out more about this better weather, with a view to fulfilling her own and Albert's dream of a family retreat in Scotland.

That this was an insistent, even urgent, need can be partially explained by the childhood experiences of both Victoria and her husband. Born only three months apart, and delivered by the same German midwife, Victoria and Albert had also each suffered an early separation from a parent.

Albert's father, the Duke of Saxe-Coburg, acquired Gotha through his

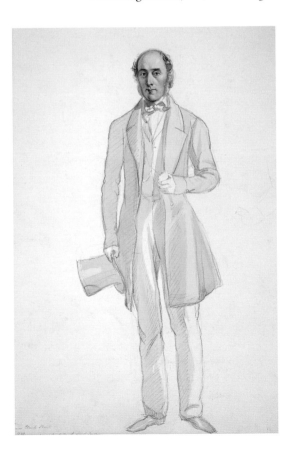

**14**

Hope James Stewart d.1883
*Sir James Clark (1788–1870), 1849*
Scottish National Portrait Gallery, Edinburgh

*The queen's physician accompanied his royal patient on all three of her early trips to Scotland. A native of Banffshire, Clark had spent several years in the Navy before completing a medical degree at the University of Edinburgh in 1817. He was instrumental in the decision to make Balmoral Victoria and Albert's royal home in the Highlands.*

first wife, Luise of Saxe-Gotha-Altenburg, whom he married in 1817 when she was sixteen. But they separated in 1824, were divorced two years later, and their sons, Albert and Ernst, only five and six years old, never saw their mother again. Disguised as a peasant, she is said to have secretly watched her children while they were taking part in a public festival. On her deathbed in Paris in 1831, she worried that her children had forgotten her. Yet neither did, and Victoria recalled that Albert remembered his mother with 'tenderness and sorrow'.

## 15

**Alfred Edward Chalon 1780–1860**
*Queen Victoria (1819–1901), 1838*
Scottish National Portrait Gallery, Edinburgh

*This painting, originally in the collection of the 2nd Marquess of Breadalbane, shows the young queen in a relaxed and informal pose.*

## 16

**Franz Xaver Winterhalter 1805–1873**
*Prince Albert (1819–1861), 1842*
The Royal Collection © 2004, Her Majesty Queen Elizabeth II

*In her journal Victoria describes the painting as 'such a beautiful picture'. Albert wears a field-marshal's undress uniform with the star of the Garter and the badge of the Golden Fleece.*

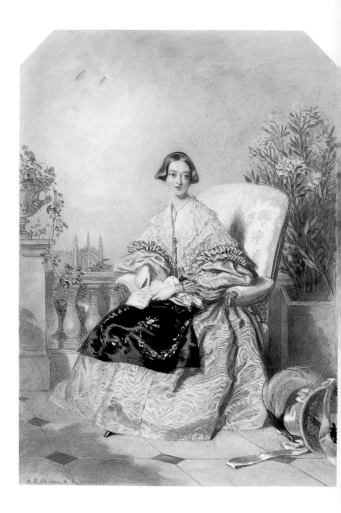

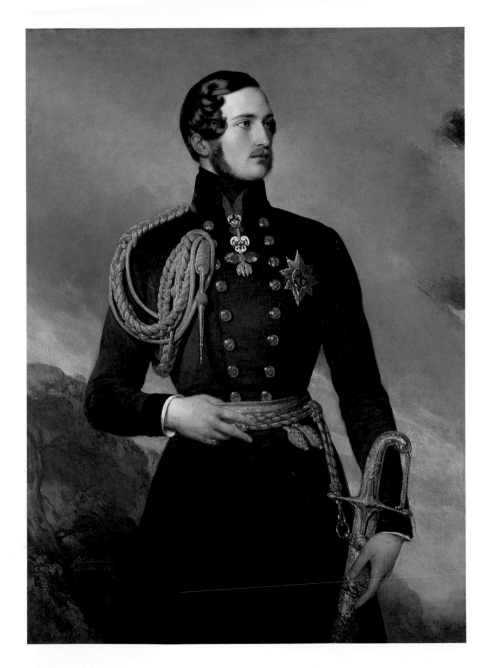

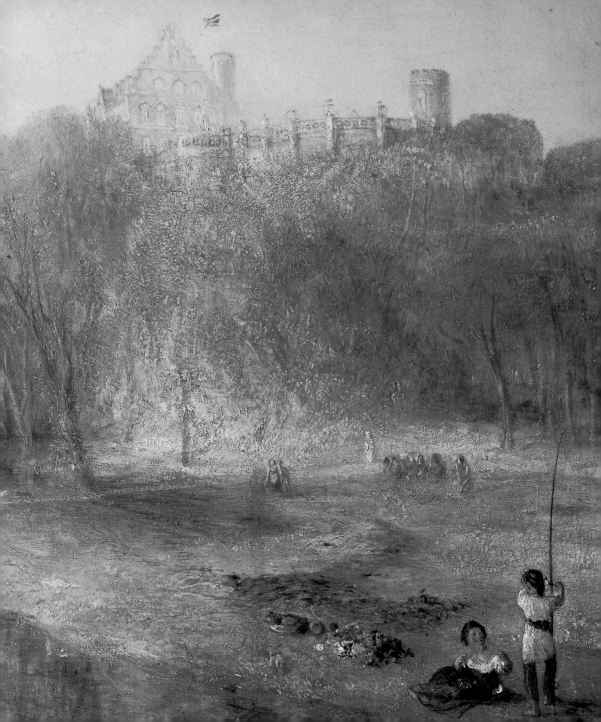

# A Family Idyll

*I had led a very unhappy life as a child ... had no brothers or sister to live with – never had a father – from my unfortunate circumstances was not on a comfortable or at all intimate or confidential footing with my mother ...*

Queen Victoria, writing to her eldest child, 9 June 1858, Buckingham Palace

Victoria's father, Edward, Duke of Kent and Strathern, died when she was only eight months old. After an uneven career in the Army, her father, who was the fourth son of George III, became governor of Gibraltar, where a fortune-teller is said to have predicted that his only child would be a great queen. In hopes of producing an heir to the throne, he left his French mistress and married Victoire, the widow of Emich, Prince of Leiningen, who already had two children. Victoria was born the following year, in 1819, at Kensington Palace, as her father was determined that his heir should be British born. Although it was considered very bourgeois, the duchess insisted on feeding the baby herself. However, widowed for a second time, her growing dependence on Sir John Conroy, comptroller of the household, strained her relationship with her daughter. Victoria fought against his attempts to increase his own power and influence by isolating her and her mother from the royal household and other members of the

court. The young princess consoled herself with her doll collection when she was upset. Many represented figures from the world of theatre, opera or ballet, a world which she found entrancing.

Unlike Victoria, Albert and his brother, Ernst, spent many happy hours riding, hunting and playing with local children in the large park surrounding the Schloss Rosenau, near Coburg, where he was born in 1819. The two boys slept in a simply furnished room that Victoria saw on her visit to her husband's birthplace in 1845. She wrote in her journal that she would always consider Rosenau her second home.

Only twenty years old when they were married, Victoria and Albert were rarely separated and their private life revolved around their family, which was to include nine children. They were not 'fashionable' and did not 'lead' society as they clearly preferred the more bourgeois blessings of domesticity, as did the rapidly growing middle classes of the country. Although they had a number of official residences and a private home on the Isle of Wight, it was only in the Scottish Highlands that they found the privacy, informality and intimacy to produce what Victoria called the *gemütlich* element so central to their ideal family home.

They needed a retreat from the political and social pressures of court and government where they could pursue their family idyll.

Sir Robert Gordon, the British Ambassador in Vienna, retired in 1846 to take up residence at Balmoral, which he had leased since 1830 from the Earl of Fife. When Sir Robert died, after choking on a fish-bone, the lease

devolved to his brother, Lord Aberdeen. In 1848 Victoria and her family leased the estate, sight unseen, which was just as Sir Robert had left it. They found the house too small, but thought it 'pretty', and they were enamoured of the scenery. When they took the lease, they also acquired Gordon's furniture, several members of his staff, and his dog called 'Monk'.

## 17

*Dolls Dressed by Princess Victoria and Baroness Louise Lehzen (1784–1870)*

*Victoria was deeply interested in the dress of fashionable women whether seen at the theatre or at Kensington Palace or in fashion plates in magazines. In 1833, when she was fourteen, all the dolls were packed away.*

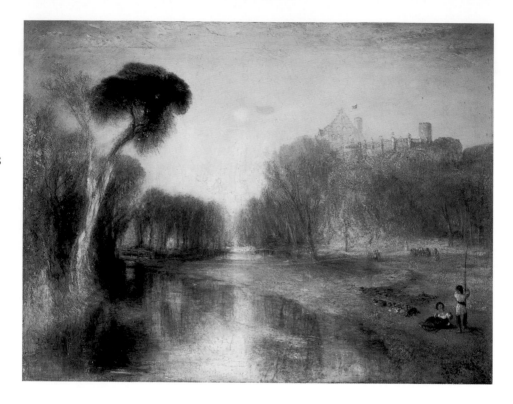

**18**

Joseph Mallord William Turner 1775–1851
*Schloss Rosenau, Seat of HRH Prince Albert
of Coburg, near Coburg, 1841*
National Museums of Liverpool (The Walker)

*When Victoria first saw her husband's birthplace
it felt, she wrote, 'like a beautiful dream' to be there
with him. Turner has captured something of that
dreamlike atmosphere in this painting, but despite
the fact that it is now considered a hauntingly
beautiful work, the painting completely failed to
attract the attention of the prince when it was
exhibited at the Royal Academy exhibition in 1841.*

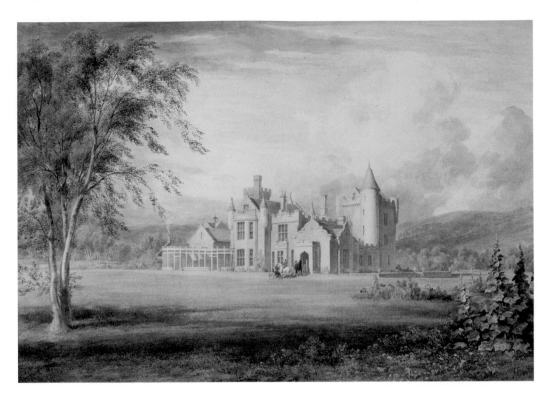

## 19

### James Giles 1801–1870
*Old Balmoral*

The National Trust for Scotland, Haddo House

*The royal couple found Old Balmoral far too small, but thought it 'pretty', and were enchanted with the surrounding scenery. Before Albert bought the property in 1852, the queen and prince took the lease of the estate for four years, acquiring the previous owner's furniture, several members of his staff, and his dog 'Monk'.*

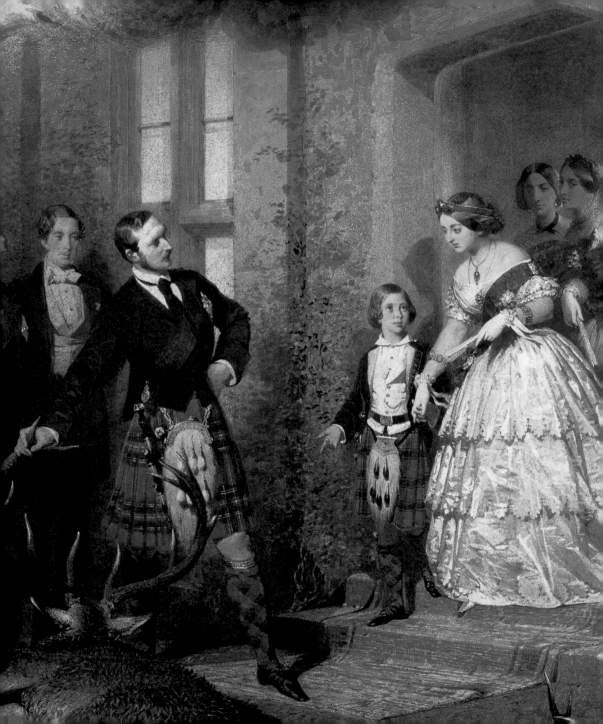

# Being at Balmoral

*Scotch air, Scotch people, Scotch hills, Scotch rivers, Scotch woods, are all far preferable to those of any other nation in or out of this world ...*

**Lady Lyttelton writing to her daughter about Queen Victoria's exuberant appreciation of Balmoral, 5 October 1849, Osborne House**

In June 1852, Albert purchased Balmoral and a cairn on Craig Gowan was erected to mark this important family acquisition. They decided to build a new castle which was to be Albert's own private residence, unlike Osborne House, which although a semi-official royal residence was the queen's private property. He situated the new house 100 yards north of the original castle in order to provide better views up the River Dee. On the exterior walls were sculpted not only the royal crests of England and Scotland, but a bas-relief showing St Hubert, patron saint of huntsmen, and Albert's personal coat of arms, as well as the gilded crests of Saxe-Coburg-Gotha. Balmoral shared several features with the Schloss Reinhardsbrunn, in Germany, which was restored by Albert's father and used as a hunting lodge. These similarities included steep roofs, castellations, crowsteps, and a particularly romantic façade.

Balmoral was to become, along with Sir Walter Scott's home in the borders,

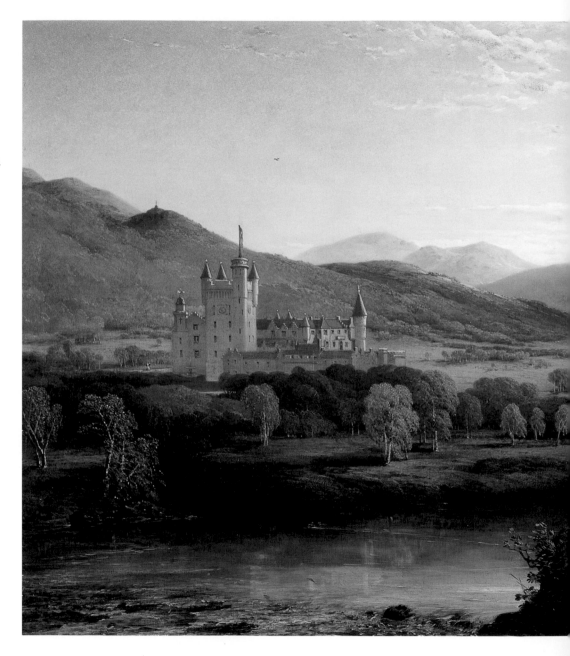

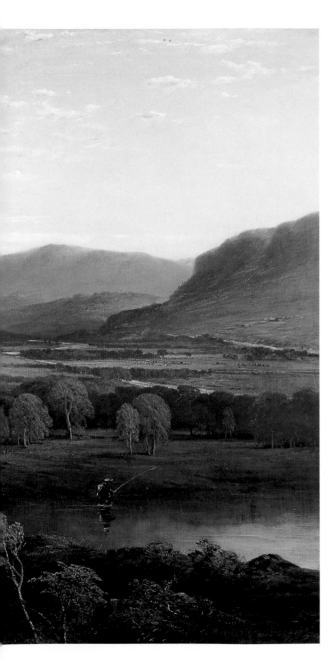

the epitome of the 'Scottish baronial' style of architecture. Aberdeen-based architect William Smith worked closely with Albert to produce the new home. His role was to translate Albert's designs and ideas on to paper, with proper specifications and modifications, and then oversee the construction. The walls were of granite, with many large windows to maximise the amount of light and air in the interior, and a hot air heating system was supplemented by sixty-seven fireplaces. Victoria and her immediate family used the four bathrooms, while a hip bath in the bedroom was standard for everyone else. Meant to house at least 100 people, the castle provided a sense of privacy for the couple and their family. Although Albert allocated an apartment for the minister in attendance, who had to be present while the queen was in residence, he made few other concessions to accom-

43

**20**

James Cassie 1819–1879
*Balmoral Castle*
Aberdeen Art Gallery and Museum Collections

*New Balmoral, which was designed by Albert with the Aberdeen architect William Smith, was to become the epitome of the Scottish baronial style of architecture. Constructed of dressed granite, it was completed in 1856.*

modate representatives of the state. Balmoral was to give him much pleasure as well as an opportunity to exercise freely his ideas on estate management. Plantations of larch, familiar to Albert from the forests of his homeland, were laid out and many improvements made to the tenant cottages. Victoria liked to 'drop in' unannounced on the women living on the estate; if they resented this invasion of their privacy, they hid it well as she noted in her journal that she was always welcomed. Albert, though an indifferent shot, remained an avid sportsman and could fully indulge his enjoyment of country pursuits on his own land.

Occasionally they left Balmoral on a number of one or two day expeditions during which the royal party travelled incognito, undertaking arduous carriage and pony treks to scenic spots in the Cairngorms and sleeping overnight at village inns where Victoria was convinced no one recognised them. She found these jaunts, which were initially Albert's idea, very refreshing.

Victoria referred to Balmoral as 'this dear Paradise'. This affection was not always reciprocated locally where to a few the presence of the queen and her predominantly English court represented a loss of nationhood. Others did not appreciate the transformation of moors and deserted crofting land into a sporting ground for foreign guns who

44

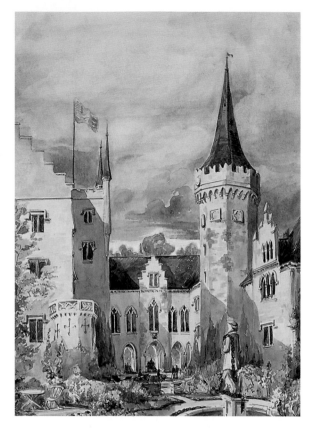

**21**

Charlotte Stuart, Viscountess Canning 1817–1861
*Schloss Reinhardsbrunn: the Entrance Courtyard*
Reproduced by kind permission of the Earl and Countess of Harewood and the Trustees of Harewood House Trust

*The royal couple visited Albert's homeland in 1845 spending several nights at Reinhardsbrunn near Gotha, which had been restored by Ernst I, Albert's father, and used as a hunting lodge. Balmoral shared several features with this castle, including steep roofs, castellations and crowsteps.*

Carl Haag 1820–1915
*Evening at Balmoral, 1854*
The Royal Collection © 2004, Her Majesty Queen
Elizabeth II

*The critics were full of praise for this
painting when it was exhibited – the
various sources of light illuminating the
manly figure of Albert displaying the
results of his sporting prowess to Victo-
ria, with the Duchess of Kent and three
ladies-in-waiting looking on.*

preferred to shoot in seemingly 'natu-
ral' deer forests. Some felt patronised
by Victoria's easy subscription to a
Scottish ethnicity through her choice of
dress, dances, picnics by the lochs and
enthusiastic patronage of Highland
games. Yet such activities helped make
the Crown more inclusive, more
'British', and less 'English'. Sir Walter
Scott's romantic literary Highlanders,
helping to promote his vision of a
culturally distinct Scotland, were
embraced by Victoria and Albert and in
doing so they offered a welcome
approval to those Scots who had
accepted this image of themselves as a
means of securing a unique identity
within the Union.

45

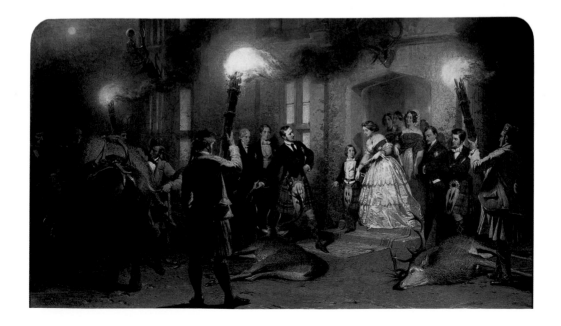

But Victoria and Albert were in thrall to the charms of the Highands. Recording through her watercolour drawings and sketches the Scottish landscape and scenes around Balmoral gave Victoria immense satisfaction. When at Balmoral, she went out sketching and painting almost every day, often finishing or refining her pictures later. In the days before the widespread use of photography, such works, along with those by some of her talented ladies-in-waiting and professional artists, provided 'souvenirs' for the queen's albums.

Albert believed that people who were born and raised in the mountains were more hardy and virtuous than those who lived at lower altitudes. Victoria was to write in her journal that 'The Prince highly appreciated the good-breeding, simplicity and intelligence, which make it so pleasant and even instructive to talk to them.' This form of nineteenth-century primitivism was embodied in the manly, competitive sports of the Highland games.

From 1848 onwards the royal princes wore Highland dress while staying at Balmoral, and occasionally the princesses wore the boys' kilts.

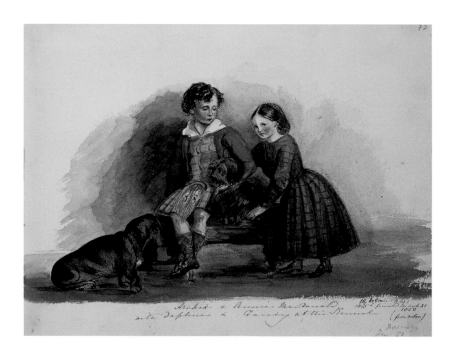

## 23

Queen Victoria 1819–1901
*Archie MacDonald (1842–1890) and
Annie MacDonald (1848–1866)*
The Royal Collection © 2004, Her Majesty Queen
Elizabeth II

*Archie and Annie MacDonald were the
children of Albert's ghillie, who came
from the west of Scotland. Archie went
on to become wardrobe man to Albert
and subsequently jäger to the Prince of
Wales. Both children were drawn by Sir
Edwin Landseer in 1851, and Victoria also
painted Annie in 1852 wearing a shawl of
Balmoral tartan.*

## 24

Queen Victoria 1819–1901
*View in the Corrie Buie, 1848*
Reproduced by kind permission of the Earl and
Countess of Harewood and the Trustees of
Harewood House Trust

*This is Victoria's copy of one of Lady
Canning's watercolours which may have
been an exercise set by her lady-in-
waiting, who occasionally gave her
watercolour lessons. It was executed on
the royal couple's first visit to Balmoral
and given to Lady Canning.*

Adult sons-in-law donned the costume and many visitors assumed that they must also wear Highland dress when on the estate. The 'Dress Stewart' tartan became wildly popular after it was adopted by Victoria and the ladies of the royal household at Balmoral. Even before acquiring the estate, Victoria had promised the manufacturers of tartan cloth, who had approached her on earlier trips, that she would do her best to make their designs more fashionable outwith Scotland. And so she did. By establishing an annual royal residence at Balmoral, the royal family greatly increased the appeal of Scotland as a tourist destination, popularised certain architectural styles, and spread the use of tartan far beyond the borders of Scotland.

The new house was finally finished in 1856. Its construction had been delayed by the outbreak of the Crimean War. Albert had wanted to be on site, but felt it would be unseemly to be seen managing the building of a family home while the queen's soldiers were dying abroad. Three days after they moved in, during 1855, a telegraphic despatch arrived with the news that the eleven-month siege of Sebastopol by British, French and Turkish forces had come to an end when Russian troops withdrew from the city. To celebrate, Albert ordered a bonfire to be lit on Craig Gowan, opposite the castle. He wrote to his old friend and adviser, Baron von Stockmar that 'it illuminated all the peaks round about; and the whole scattered population of the valleys understood the sign, and made for the mountain, where we performed towards midnight a veritable Witches' dance supported by whisky.' In the autumn of that year, during an informal ride on the estate, the young Prince Friedrich Wilhelm of Prussia (the future Emperor of Germany) picked a sprig of white heather, and handing it to Victoria and Albert's first-born child asked the fourteen-year-old princess royal to marry him. Baron von Moltke, acting as personal aide-de-camp to the crown prince of Prussia, wrote to his wife about Balmoral while staying there on 30 September 1855: 'It is very astonishing that the Royal power of England should reside amid this lonesome, desolate, cold mountain scenery, and almost unbelievable that the most powerful monarch should get rid of all state to such a degree. It is a simple family party here …' The crown prince and Von Moltke were the first to sleep in a suite of rooms reserved for special visitors, thus inaugurating a distinguished guest list.

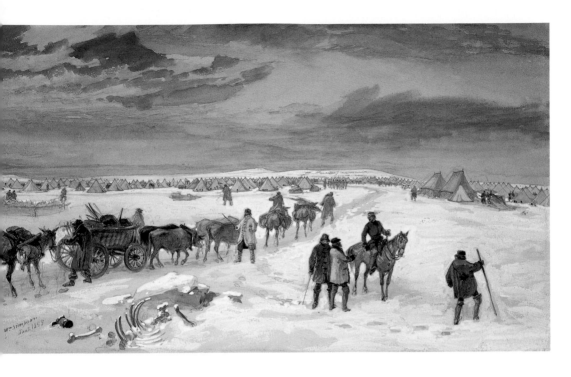

49

**25**

**William Simpson 1823–1899**
**Camp Divison, Crimea**
National Gallery of Scotland, Edinburgh

*Known as 'Crimean Simpson', the
Glasgow-born painter became a pioneer
war artist. Victoria was much distressed
by reports of the suffering of her soldiers
and when Simpson showed her his
sketches he was impressed by her grasp of
the details of the war.*

**26** overleaf

**John Phillip 1817–1867**
*Study for the Marriage of the
Princess Royal*
Aberdeen Art Gallery and Museum Collections

*The princess royal was only fourteen
when she became engaged to Prince
Friedrich Wilhelm of Prussia at Bal-
moral in 1855. This view of the marriage
ceremony, which took place in January
1858, is taken from beside the comm-
union table looking towards the entrance
door of the chapel royal at St James's
Palace.*

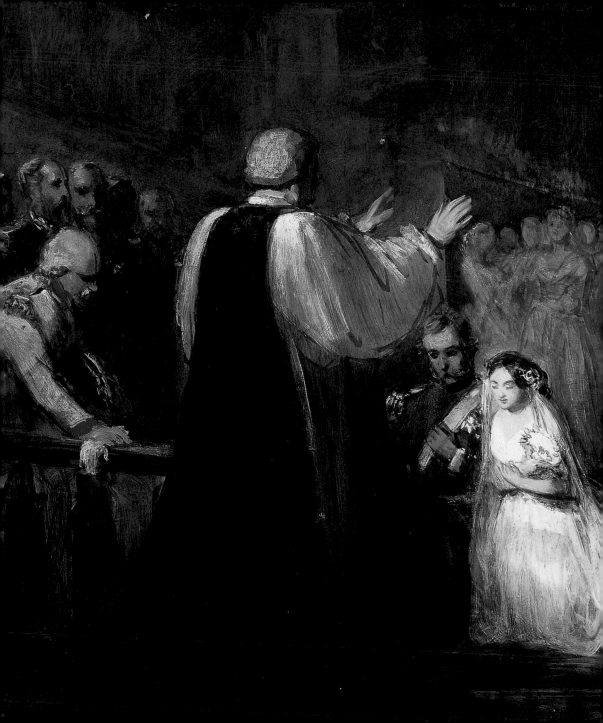

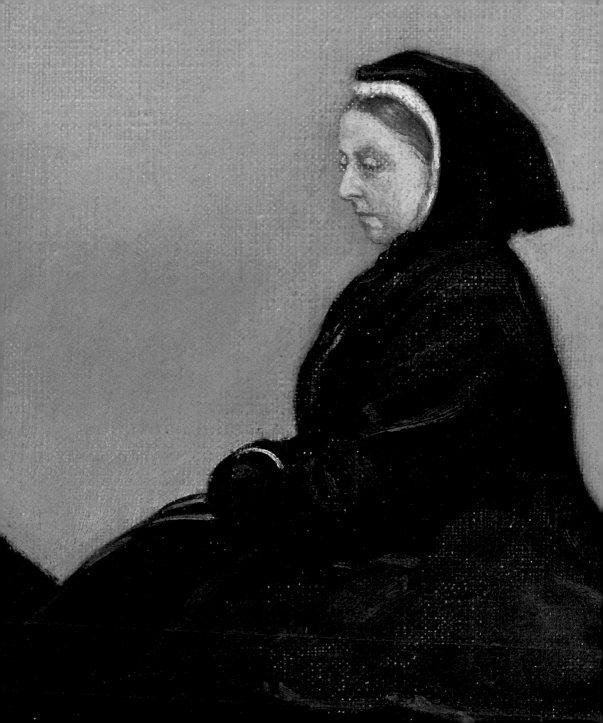

# End of the Idyll

*I need hardly tell you that there is a change ... How different from my first visit here – the joyous bustle in the morning when the Prince went out ... Now all is gone with him who was the life and soul of it all.*

William L. Leitch, Queen Victoria's drawing master, describes Balmoral after the death of the prince consort, August 1862, Balmoral

They were to have only another few years of such happiness at their Scottish haven. The Duchess of Kent died in March, 1861 and Victoria was deeply affected by her mother's death. Then,

within months, Albert was dead and Victoria was consumed by grief.

After Albert's death few alterations were made to Balmoral Castle, and over the remainder of her own life Victoria lived surrounded by Albert's taste and vision of their Highland home. Indeed, his private rooms at Balmoral, along with those at Windsor and Osborne, were to be kept as he had left them. In his memory she erected a cairn and in 1867 presented to her Balmoral tenants a large bronze statue of the prince consort in Highland dress, with gun and retriever. She ordered some of Albert's projects, such as an estate dairy, which were unfinished at his death, to be completed. The finality of her loss could explain her decision, against the advice and wishes of her children, to publish, in 1868, her nostalgic best-selling *Leaves from the Journal of Our Life in the Highlands* and to rebuild Glasallt Shiel, at the end of Loch Muick, as a 'widow's house'. The family idyll in the Highlands was over.

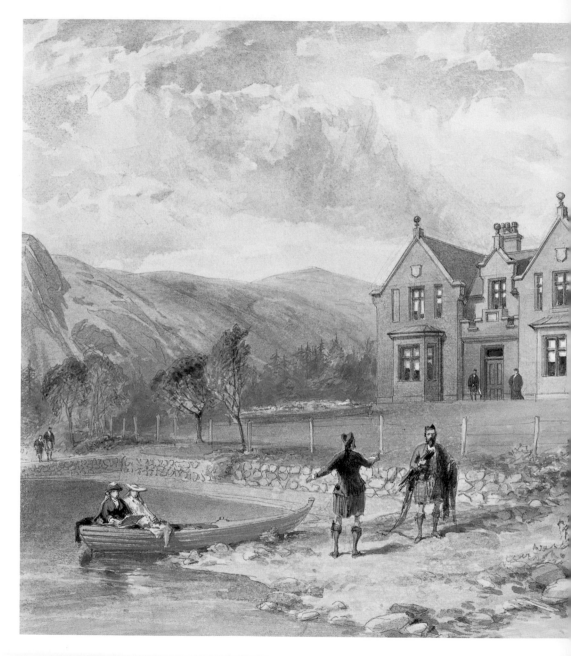

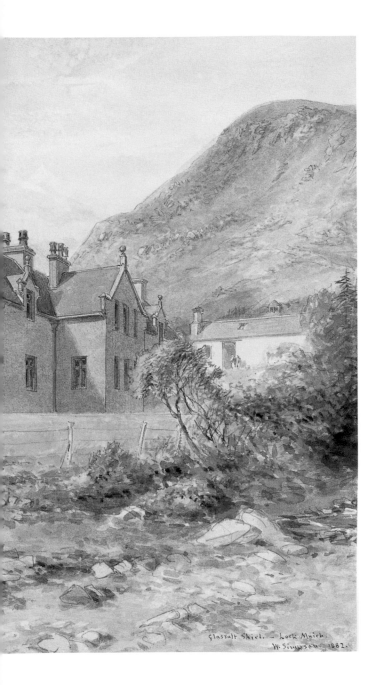

Glassalt Shiel. – Loch Muich.
W. Simpson. 1882.

**26**

William Simpson 1823–1899
*The Glasallt Shiel*, 1882
The Royal Collection © 2004,
Her Majesty Queen Elizabeth II

*This small keeper's lodge at the
upper end of Loch Muick was
enlarged after Albert's death so
that Victoria could spend time
there. Victoria, with John
Brown, stands at the door of
the lodge.*

## Sources

A.C. Benson and Viscount Esher (eds.), *The Letters of Queen Victoria, 1837–1861*, 3 vols., London, 1907

Roger Fulford (ed.), *Dearest Child: Letters between Queen Victoria and the Princess Royal 1858–1861*, London, 1964

Arthur Helps (ed.), *Leaves from the Journal of Our Life in the Highlands*, London, 1868

Kurt Jagow (ed.), *Letters of the Prince Consort 1831–1861*, London, 1938

A. MacGeorge, *William Leighton Leitch, Landscape Painter: A Memoir*, London, 1884

J.R. McIlraith (ed.), *Moltke's Letters to his Wife and Other Relatives*, vol.1, London, 1896

Mrs Hugh Wyndham (ed.), *Correspondence of Sarah Spencer, Lady Lyttelton 1787–1870*, London, 1912

56